CYPRUS
BEFORE THE BRONZE AGE

ART OF THE CHALCOLITHIC PERIOD

THE J. PAUL GETTY MUSEUM

MALIBU, CALIFORNIA

1990

Catalogue of an exhibition held at the J. Paul Getty Museum, Malibu, February 22–April 8, 1990; The Menil Collection, Houston, April 27–August 26, 1990.

Lenders to the exhibition: Cyprus Archaeological Museums; The Menil Collection, Houston; The J. Paul Getty Museum, Malibu.

© 1990 The J. Paul Getty Museum
17985 Pacific Coast Highway
Malibu, California 90265
Mailing address:
P.O. Box 2112
Santa Monica, California 90406

Christopher Hudson, Head of Publications
Cynthia Newman Helms, Managing Editor
Karen Schmidt, Production Manager
John Harris, Editor
Kurt Hauser, Designer
Orlando Villagrán, Typographic Coordinator
Elizabeth Burke Kahn, Production Coordinator

Maps of the eastern Mediterranean and of Cyprus drawn by Beverly Lazor–Bahr

Printed by Alan Lithograph

Cover: Cruciform figure of limestone, said to be from Souskiou. Malibu, J. Paul Getty Museum 83.AA.38 (cat. 13). Photograph : Ellen Rosenbery.

Figs. 1-6, courtesy Lemba Archaeological Project. The photographs in the catalogue section are courtesy of the Cyprus Museum, Nicosia, with the exceptions of cat. 13 and the cover illustration, which are from the J. Paul Getty Museum, and cat. 29, 32, and 35, which are from the Menil Collection (photographs courtesy Hickey and Robertson, Houston).

Library of Congress Cataloging-in-Publication Data

Cyprus before the Bronze age: art of the Chalcolithic period / the J. Paul Getty Museum.
 p. cm.
 ISBN 0-89236-168-9
 1. Copper age—Cyprus—Exhibitions. 2. Cyprus—Antiquities—Exhibitions.
I. J. Paul Getty Museum.
GN778.32.C9C97 1990
939' .37—dc20 89-24543
 CIP

Contents

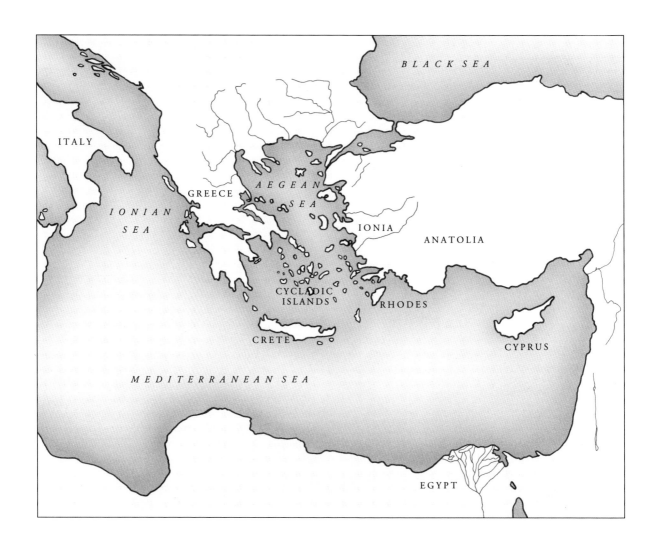

The eastern Mediterranean.

Directors' Foreword

THROUGH THE EFFORTS of Dr. Vassos Karageorghis, Director of
the Cyprus Department of Antiquities for a quarter of a century until
1989, Cypriot art and archaeology have achieved international recogni-
tion. Symposia and loan exhibitions from Cyprus have given a clearer
and more detailed picture of the history of the island to an ever-wider
audience. This exhibition offers Americans a rare chance to see exam-
ples of the art of prehistoric Cyprus. The small and beautifully mod-
eled figures of highly polished picrolite and other important archaeo-
logical material help to explain one of the least-understood periods of
Cypriot prehistory, the Chalcolithic. We are delighted that these
thirty-two objects from Cyprus also include the "Lemba Lady," the
only known large-scale limestone idol other than the one at the Getty
Museum.

We are deeply indebted to Dr. Karageorghis, currently Advisor to
the President of Cyprus on Cultural Property, for initiating the exhibi-
tion and proposing a symposium on Chalcolithic Cyprus when he visi-
ted the Getty Museum in 1987. The Cyprus Department of Antiqui-
ties, whose Acting Director is now Mr. Athanasios Papageorghiou, and
the museums of Cyprus have been generous in lending important,
recently excavated material from the Neolithic and Chalcolithic per-
iods. Dr. Dimitri Michaelides was helpful in selecting material from
the Paphos Museum.

Mr. M. Loulloupis, Curator of the Archaeological Museums and
Surveys of Cyprus, has been unselfish with his time in facilitating the
loan of the objects and the preparation of the catalogue. Dr. Edgar
Peltenburg, Director of the Lemba Project and Reader in Near Eastern
Archaeology at the University of Edinburgh, has written the essay on
Chalcolithic Cyprus and provided helpful comments during the com-
pilation of the catalogue; Dr. Pavlos Flourentzos, Archaeological
Officer of the Cyprus Department of Antiquities, has written the en-
tries for the Cypriot material; and Susan Davidson has compiled the
entries for the Menil Collection. The manuscript was prepared by
Dorothy Osaki, Senior Secretary in the Department of Antiquities,
and the publication was seen through production by John Harris,
Associate Editor, both of the J. Paul Getty Museum.

To all those just mentioned, and to curators Marion True and
Bertrand Davezac, we offer our admiration and gratitude.

John Walsh, Director Walter Hopps, Director
J. Paul Getty Museum The Menil Collection
Malibu, California Houston, Texas

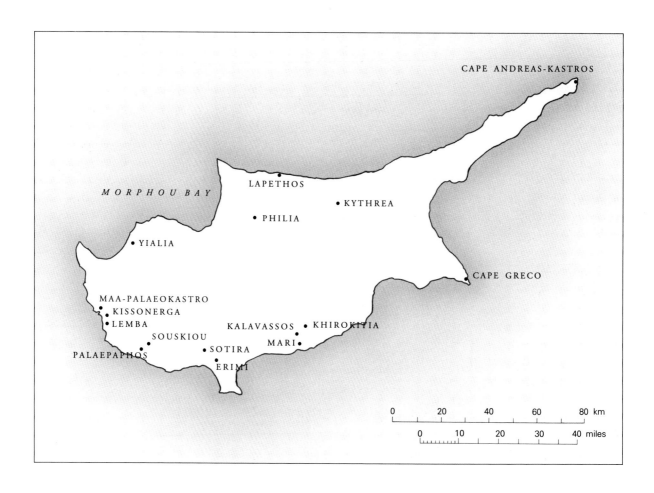

Neolithic and Chalcolithic sites on Cyprus.

Introduction

SINCE THE DISCOVERY and investigation of the Neolithic and Chalcolithic cultures of Cyprus by my predecessor Porphyrios Dikaios nearly fifty years ago, much new information about these cultures has emerged thanks to excavations and new methods of dating. Of the two periods, the Neolithic has, until recently, received far more attention, perhaps because of the many unsolved problems, chronological and other, connected with it. Apart from Khirokitia and Sotira, where the initial investigations were carried out, at least two new settlements were excavated, at Cape Andreas and Kalavassos-Tenta. The Chalcolithic period, on the other hand, known mainly from the limited excavations at Erimi and stray finds from other sites, was considered a transitional period of short duration between the Stone Age and the Bronze Age, and many scholars felt that its material culture had very little of significance to offer.

This picture has changed dramatically during the last fifteen years. Although the Chalcolithic site at Souskiou-Vathyrkakas near Palaepaphos was severely damaged by looters, it has produced some extraordinary objects, mainly from tombs, which increased considerably not only the repertory of Chalcolithic art (pottery, terra cottas, stone statuettes) but also our knowledge about Chalcolithic culture in general. Scholars were attracted by this new influx of material, and several studies were undertaken, not only of the new material but also of objects kept for many decades in museums.

It is not, therefore, surprising that new, systematic excavations were planned and carried out at sites that have been discovered since the excavations at Erimi. The results of these excavations have been the revelation of the robust, sophisticated, and lively physiognomy of Chalcolithic Cyprus. At Kalavassos-Ayious a limited excavation sponsored by Brandeis University and led by Ian Todd uncovered mysterious tunnels (perhaps used for habitation) and a new repertory of objects (pottery and terra cottas). It was in the Paphos District, however, that the most exciting excavations were carried out. A well-planned project to investigate the area north of Paphos, known as the Lemba Project of the University of Edinburgh and led by Edgar Peltenburg, has been offering us surprising results since 1976. At Lemba-Lakkous first, and then at Kissonerga-Mosphilia and Mylouthkia, new evidence has been uncovered, including impressive architectural remains, burials, stone artifacts, pottery, terra cottas, copper objects, and even beads of faience—unique testimonies of the daily life, religious beliefs, and social structure that help to make the

Chalcolithic period one of the most fascinating phases of Cypriot pre-history. As a result of these excavations, together with investigations at Maa-Palaeokastro and a surface survey in the area adjacent to Lemba and Kissonerga, the southwestern part of Cyprus, from Erimi to Maa-Palaeokastro, is now known to have been an important cultural center for a period lasting about 1,500 years. The Chalcolithic period is no longer considered a secondary transitional period but one of utmost importance in its own right. The study of this era's relationship with the Late Neolithic and Early Bronze Age has begun, and several excavation reports and syntheses have already been published. I would predict that this period, together with the Late Bronze Age, will dominate archaeological research in Cyprus for the next decade at least.

It was natural, therefore, that the need for a conference on Chalcolithic Cyprus should be felt. In 1987, on a visit to Malibu, we discussed with the director of the J. Paul Getty Museum and his colleagues the possibility of organizing such a conference at the Museum early in 1990, its purpose being a general survey of the Chalcolithic phase of Cypriot prehistory. The interest of Director Walsh and his associates was increased even more by the presence in their collection of a major work of Chalcolithic stone sculpture from Cyprus; the idea for a conference was eagerly accepted. In addition, a suggestion that I put forward for the organization of a small exhibition of Neolithic and Chalcolithic objects from Cyprus was approved by the government of Cyprus, and thus the "Malibu Lady" (the stone statuette referred to above) will play host to a number of relatives from home.

To all those who worked on the organization of the conference and of the exhibition, and particularly to the Getty Museum's Director, John Walsh, and to Marion True and Kenneth Hamma of the Department of Antiquities, as well as to my colleagues in the Cyprus Department of Antiquities, we express warm thanks. We should also mention the assistance of Walter Hopps of the Menil Collection (Houston), who, together with Marion True and myself, selected the objects in the museums of Cyprus. I hope that the exhibition and the proceedings of the conference will foster the study of the culture of Cyprus among scholars. I also hope that they will inspire the sympathy of the American people, who have recently seen evidence of the ways in which the rich cultural heritage of Cyprus has suffered as a result of invasion and occupation. We hope that the proceedings of the conference along with the catalogue of the exhibition will constitute the first handbooks on Chalcolithic Cyprus.

Vassos Karageorghis
Advisor to the President on Cultural Property, Cyprus
Former Director of the Cyprus Department of Antiquities

Chalcolithic Cyprus

Edgar J. Peltenburg

THE PERIOD OF some 1,500 years from about 4000 to 2500 B.C.
witnessed unprecedented developments in the history of Cyprus.
There is clear evidence for a significant growth in population and
the emergence of social ranking. Copper was used for the first time
on the island whose later prosperity and very name were to become
synonymous with that enviable resource. Metallurgy and social
hierarchies have often brought conflict with them, yet fortifications
and weaponry were entirely lacking in this period. Throughout the
island, settlements of varied size, none of which could be classed as
urban centers, consisted of novel circular buildings that strike one as
anachronistic insofar as there had been a tendency to rectangularity
in the preceding Neolithic period. Once established, this circular
architecture remained the norm for over a millennium. Amidst
these innovating and conserving tendencies there arose highly dis-
tinctive sculptural traditions that mark the zenith of artistic achieve-
ment in Cyprus before the Bronze Age. Despite the evidence for oc-
casional overseas contacts, the island's flourishing Erimi Culture, so
named after a type-site near the south coast, remained essentially
unaffected by foreign influence.[1]

Recent research has demonstrated that the conventional division
of this lengthy epoch into periods known as Chalcolithic I and II is
no longer capable of satisfactorily encompassing all the evidence,
and hence some modification is called for. In particular, we need to
take into account the discovery of a formative stage (which could
only be vaguely discerned at the key site of Erimi) and a much better
defined post-Erimi stage. So distinctive are these episodes that,
without wishing unduly to separate what was essentially a cultural
continuum, it will be useful to refine the traditional scheme pro-
posed by Porphyrios Dikaios into Early, Middle, and Late Chal-
colithic periods.[2] Such a refinement, it should be emphasized, is
necessary if we are to grasp the causes of change and evolution in
what must be regarded as one of the most distinctive and artistically
prolific prehistoric societies of the Mediterranean region. It should
also be stressed that because so few sites of this neglected period
have been investigated, any reconstruction must still be regarded
as tentative.

EARLY CHALCOLITHIC PERIOD

(circa 3800-3500 B.C.)

EARLY SETTLEMENT PATTERNS on Cyprus are characterized by repeated shifts of locale. Continuous settlement drift suggests chronic instability, perhaps due to the inability of the society to exploit its resources sufficiently to cope with increased population. There is some reason to believe that a more general dislocation took place at the beginning of the fourth millennium B.C. In contrast to most Late Neolithic sites before that time, subsequent occupations have failed to yield upstanding stone architecture, suggesting a major change in settlement type. Moreover, these sites produced new styles of pottery and other artifacts, several of which have proved to herald long-lived traditions. It is, therefore, a formative period in which many critical changes took place.

Early Chalcolithic sites such as Kissonerga-Mylouthkia and Kalavassos-Ayious largely comprise hollows, pits, and tunnels.[3] Arguments that these are the subterranean components of eroded settlements that once possessed highly perishable structures have recently been bolstered by the extensive occurrence of daub and postholes at Maa. Suggested reasons for such apparently radical settlement transformations include changes in economy, the establishment of new sites in territory requiring woodland clearance with timber re-usage, and environmental deterioration. By themselves such reasons are not very compelling, but a combination of these and other factors may underlie the observed developments. Subterranean hollows and tunnels are in any case well-attested features in Late Neolithic times.[4]

In spite of their unpretentious nature, these pit-sites have yielded a most informative range of artifactual evidence. Ceramics, worked bone, and ground-stone tools and vessels, while exhibiting a stylistic evolution, are thoroughly in harmony with earlier insular traditions. Even the prodigious output of ceramic and stone figurines, stone pendants, and the advent of metalwork may be explained in insular terms. We may thus exclude foreign inspiration for the genesis of Chalcolithic Cyprus.

Recovered figurines are mostly fragmentary, yet the painted designs on the legs, the elliptical heads with only the eyes and nose articulated, and the short, flange-like extensions for the arms are all incipient features of later canonical types.[5] Comparison with anthropomorphic representations from the Late Neolithic shows a vast increase in production, a new tendency toward the delineation of a

specifically human form (usually female), and the use of clay. While it is clear that coroplastic art in Cyprus, a major form of expression in antiquity, commenced at this time, so confidently schematized are the figures that the origins of the style presumably existed in other, perishable mediums. Fragments of zoomorphic vessels confirm that the plastic qualities of clay were being exploited as never before and that the fantastic creatures from later Souskiou also belong to a terra-cotta tradition that was established at this time.

The development of new modes of expression is also evident in the production of pendants in bone, shell, and above all picrolite, a soft stone akin to steatite, the finest examples being a vivid blue-green.[6] This stone, the hallmark of Chalcolithic Cyprus, was used previously, but only for uninspired plain pendants. Now the repertory was expanded in several directions, including incipient cruciform-shaped figurines. The intensified exploitation of picrolite may have been instrumental in a major discovery, copper.

Located around the Troodos Massif in a zone known as the "copper belt" and in smaller pockets elsewhere are surface exposures of copper with bright, attractive colors. In some cases the sources lie close to picrolite seams. Both materials were subject to erosion by rivers, and their distribution was thereby extended in certain drainages. That a copper artifact, in the form of a hook from Mylouthkia, occurs at this time may well be explained in the context of a determined search for picrolite.[7] However, it has also been suggested that the trace-element composition of the hook is unlike analyzed native coppers of Cyprus.[8] While further analyses of this unique object are desirable, its composition raises the intriguing possibility that sources outside the copper belt area were being exploited or that copper was one of the earliest materials imported to Cyprus. Even were that to be the case, it is hardly enough to sustain arguments for extensive foreign contacts, and so the most satisfactory explanation for the diverse changes in this formative period is likely to be found on Cyprus itself.

MIDDLE CHALCOLITHIC PERIOD
(circa 3500-2800 B.C.)

WITH THE APPEARANCE of conventional settlement and funerary evidence in the archaeological record, it becomes easier to consider cultural developments in their social setting and so move from description to interpretation. A model commonly deployed by explicitly deductive archaeologists to interpret their data is that of anthropologically observed societal types such as tribes and chiefdoms. The former is characterized by a largely egalitarian social structure based on a domestic mode of production; the latter by a two-tier social hierarchy with differential access to resources, and centers for the redistribution of economic goods and ritual activities. In terms of material culture these societal types are often suggested by sites of similar size with little evidence of craft specialization, or by sites of different size with storage centers and public structures such as temples. There may well have been other forms of social evolution in antiquity, but we may at least observe clear signs of the emergence of social ranking in this phase of the Chalcolithic, if not before.

Lemba Period I is the earliest Chalcolithic site with wall foundations. Here, circular structures with central platform hearths reveal what was to become the architectural pattern for Cyprus until circa 2300 B.C. Houses were small, approximately three meters in diameter. Built with pisé, that is, rammed earth, foundations, they were interspersed with graves below a terrace that also contained pit burials. Although there were no grave-goods or stratigraphy to link the two parts of the site, it is inherently likely that the two were contemporary and that located on the upper terrace is the earliest cemetery in Cyprus. In a number of cases the buildings were located over roughly circular pits of the same size, and this congruence, which can be interpreted as a desire to place structures in the protection of existing hollows, may account for the distinctive circular building tradition of Chalcolithic Cyprus.[9]

Later sites, such as Lemba II, Lapithos, Kythrea, and Erimi VII-XIII, have much more substantial and permanent structures with stone wall bases. They are sometimes twice as large as the Lemba I buildings and there are signs of intra-site differentiation, with annexes at Erimi and the juxtaposition of large circular with small rectilinear buildings at Kissonerga-Mosphilia, for example.[10]

The much larger structures of Kissonerga merit special attention. Its Building 2 has a diameter of over ten meters and an internal area of seventy-seven square meters. Adjacent to it is part of

an even larger structure with radial walls supporting a roof span of a minimum of fifteen meters and rooms with red-painted floors and walls. Since no site of this period has been completely excavated, it is still uncertain if this outsize group of structures is unique to Kissonerga or was a component of other sites. Whatever the case, the group argues for the existence of impressive engineering skills and a sector of society that had privileged access to the required labor. That the earliest pithoi in Cyprus should be associated with these exceptional structures is also significant in terms of the control of stored bulk commodities.

This slender hint of inter-site, perhaps territorial, differences is corroborated by variations in artifact assemblages and in funerary practices. Single-inhumation pit burials with few if any grave-goods continued to be placed inside settlements. At Souskiou, however, two or three cemeteries provide a sharp contrast to other burials of the period in terms of their deep, bell-shaped shafts, multiple interments, and rich funerary furniture. Grave-goods include fantastic zoomorphs such as a centaur and askos, dentalium shell necklaces with multiple cruciform pendants, and a metal tube.[11] Much of this may be regarded as evidence for the interment of high-status goods. When set against the poverty of other burials, it seems once again as if certain sites enjoyed a special status.

More frequent ritual activity serving broad social functions can be another sign of ranking in society. For this reason the discovery of a ceremonial area at Kissonerga is highly relevant. It comprises pits filled with ash and heat-cracked stones; in addition, some have stacks of pottery bowls with, in one case, a cache of nineteen figurines, a model stool, an intact triton shell, and twenty-seven stone tools. Most of these objects were packed inside a model of a building with a detachable door that swung on a pivot, a central hearth, radial floor partitions, and walls with unique painted designs. These walls had been concealed by a thick monotone slip. Protomes over its entrance had been deliberately damaged, just as many of the fragmentary figures show signs of intentional breakage. Three of the figures are seated on what must be regarded as birthing stools since one female figure has the head and arms of an emerging child painted on a panel inset between its legs. Such a concentration of sacred ritual in a public area clearly transcends household activities, even if it does not seem to have occurred in a defined holy precinct.[12]

It would seem from the foregoing that there was differential access to wealth and some form of social ranking in Middle Chalcolithic Cyprus.

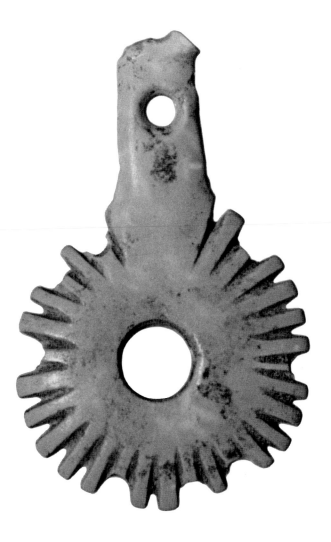

Figure 1. A unique twenty-eight-rayed bar-and-disk pendant found with a dentalium necklace belonging to a child (age one to two years). Grave 47 at Lemba-Lakkous, circa 3000-2500 B.C.

The flourishing nature of Cyprus at this time is epitomized by the abundance, sophistication, and variety of its sculptural and coroplastic art. Anthropomorphs were executed in several kinds of stone, plain terra cotta, painted pottery, and bone.

The most distinctive anthropomorphs were cruciform pendants of picrolite. The short necks, flange-like arms, and drooping legs of Early Chalcolithic figures were now developed into classic cruciforms: elliptical heads, long necks with pronounced Adam's apples, elongated bar-like arms, and legs sharply drawn up at the knees (cat. 31). Facial features, if articulated, typically comprised relief squares for the eyes separated by a disproportionately long relief rectangle for the nose. Arms were sometimes imaginatively transformed into second figures (cat. 30). Large versions were suspended at the neck, as depicted on the Yialia figure, smaller ones on necklaces that could also carry other pendants, such as the unique twenty-eight-rayed disk from Lemba (fig. 1; see also fig. 2). The nature of picrolite, an ultrabasic rock occurring as thin seams or as small pebbles in river–beds, precluded the creation of statuary in this medium.[13]

In order to fashion larger-scale representations, sculptors

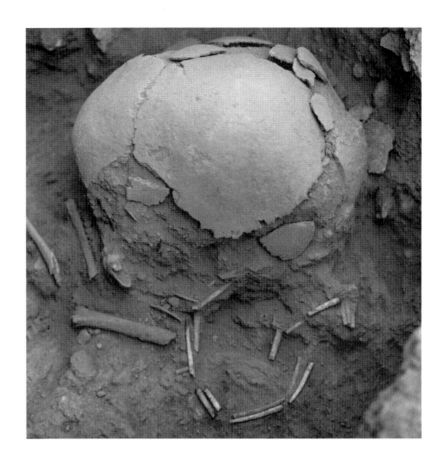

Figure 2. The only intact denta-
lium necklace of Chalcolithic
Cyprus, belonging to a child.
Grave 47 at Lemba-Lakkous,
circa 3000-2500 B.C.

worked in soft local limestone. Currently only two examples are
known, the disturbing "Lemba Lady" (cat. 12) with its phallus-
shaped neck and head, and the elegant Getty Museum figure (cat.
13), each approaching forty centimeters in height. Though preserv-
ing many of the salient features of the cruciforms, they were clearly
too large to function as pendants. The lack of stylistic homogeneity
in works in this and other rock types is made evident by smaller
representations that include coarsely modeled figures with stump
arms, totally plain cross-shapes, figures resembling gingerbread
cutouts, and more naturalistic females with outspread arms and
phalluses. Sexual dimorphism may be suspected in many of the
figures. All kinds of rough or water-worn pebbles suggestive of the
human form were also collected.[14]

Our appreciation of the range of the ceramic anthropomorphs
has, until recently, been severely hampered by the fragmentary
nature of the surviving figures. Females predominate, with disk-like
heads bearing facial features that range from the abstract to the
naturalistic, with outstretched arms and elaborately painted torsos,
some with surprisingly realistic modeling (cat. 17, 18). They were
found in large numbers at Erimi, where in spite of the deep strati-
graphy there is little evidence for an evolution of types. Complete
but less securely provenanced figures include lactating females and a

hollow seated male with erect penis. His projecting eyes, thick lips, hands raised to head, and seated posture on a stool—features that might once have been regarded as atypical—may now be seen as part of the Cypriot repertory thanks to the more intact figures of the Kissonerga ritual deposit.[15]

Of the nine ceramic figures from the Kissonerga deposit, three are seated on stools, three stand unaided, and three are hollow (and hence are perhaps more accurately to be classed as vessels). Those with articulated disk heads are elaborately painted and up to twenty centimeters in height, with cylindrical bodies and arms outspread. The plain-headed figures are hand-sized cylinders with undifferentiated legs, arms once more extended. The putative vessels are more varied: a bag-shaped kneeling female, a corpulent standing female with arms raised to her shoulders, and a male with conical eyes, protruding nose, and pouting lips punctured and outlined in red. Even this cache can only hint at the remarkable variety of contemporary figurative expressions, for there are also the fantastic creatures from the Souskiou cemeteries mentioned above.

With the exception of the last, all figures seem clearly related to aspects of sexuality, fertility, and parturition. This may not be so obvious from the picrolites, but their carefully drawn-up knees are identical with the posture of the Kissonerga birthing figures. The picrolite image is thus a schematized version of the Kissonerga figures, symbolizing successful birth. Their characteristic outstretched arms, however, are not exclusively associated with birth, for ithyphallic males also possess them (cat. 21).[16] If we allow the picrolite images' general association with procreation, then their use may tell us something of their deeper significance, for example, as dolls or deities.

Picrolite pendants occur in graves and settlements (cat. 23). That they were worn in life and are not simply derived from disturbed graves inside settlement areas is evident from the extensive wear marks in their perforations. No data is available for their association with male or female interments, but the fact that the Yialia female, like certain terra cottas from Kissonerga, is wearing a pendant that bears the likeness of another female with identical features suggests that the pendants were worn as feminine apparel.

Of the other stone figures, only the "Lemba Lady" and those from the Kissonerga ritual deposit have in situ find-spots. This class of object was not intended for burial with the dead. The "Lemba Lady" lay behind some pithoi over a groove that may have been a room partition (figs. 3, 4).[17] It was seemingly in storage in a building that is otherwise distinguished by its isolated position in an

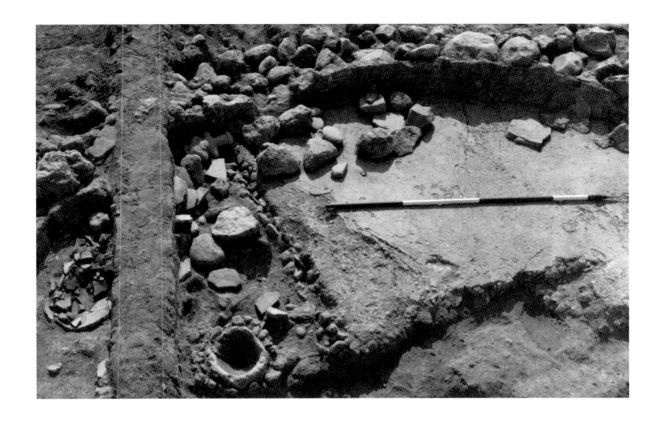

Figure 3. The "Lemba Lady" in situ against the back wall of Building 1 at Lemba-Lakkous, circa 3000 B.C.

Figure 4. Detail of the "Lemba Lady" in situ over a stone-lined channel in the floor of Building 1 at Lemba-Lakkous, circa 3000 B.C.

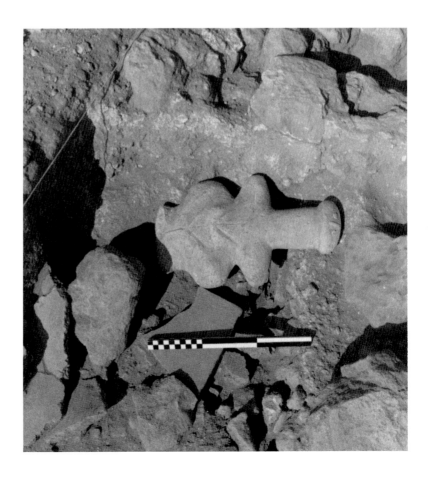

earlier burial ground and on a terrace edge. That location suggests the building's special status, since other buildings were clustered, often at the back of terraces. The Getty Museum figure may also have come from a special, nonmortuary context.

The remaining stone and ceramic anthropomorphs have been found only in habitation levels. Their concentration inside a building model at Kissonerga points to contemporary usage in an unconventional structure supplied with a focal platform opposite the door. This architectural arrangement and the associated triton shell are reminiscent of features of Bronze Age sanctuaries, but it is difficult to identify which, if any, of the figures might represent a cult statue. It should be noted that only the ceramic figures could stand unaided and therefore only they could fit on the building model platform. This indirect evidence for a sacred place is tantalizing but hardly conclusive. It may not be too speculative, in the light of the associated equipment and public ritual that involved fire, ocher-smearing, and deliberate breakage in an extramural setting, to suggest that these groups were more than mere toys and were probably more than charms or amulets.

This exuberant representational art of Cyprus in the fourth and third millennia B.C. is sui generis. It lacks the animal imagery that occurred so pervasively in the adjacent Asiatic repertories. To that extent, and in its development of a readily identified and highly schematized canonical type, its sudden appearance, and its dearth of male depictions, the art of Cyprus parallels roughly contemporary Early Cycladic I and II art and its forerunners. Correspondences even extend to composite, acrobatically arranged sculptures.[18] Stylistically, however, the similarities to the Cycladic marbles and to their Anatolian counterparts remain superficial, and we have noted an autonomous evolution of Cypriot forms from Late Neolithic precursors.

LATE CHALCOLITHIC PERIOD
(circa 2800-2300 B.C.)

CONSIDERATION OF THE final period of Chalcolithic Cyprus is inevitably bound up with one of the most controversial aspects of Cypriot prehistory: the nature of the remarkable changes that took place in the transition to the Early Bronze Age.[19] After that transition we are confronted by radically new settlement patterns and architecture, new burial customs, pottery styles, metalwork, and spindle whorls: in other words, virtually a completely new material culture and clear evidence for an altered economy and a new religious expression. In order to understand how these changes came about, we need an accurate and detailed knowledge of pottery styles and other classes of material evidence leading up to and including this critical transition. Because there is no fixed chronological framework for the many relevant assemblages, such knowledge is precisely what has been lacking. Therefore, it is necessary to identify as far as possible the nature of Late Chalcolithic sites and their relationship to each other.

To what extent did the Erimi Culture persist into the Late Chalcolithic? Both Lemba and Kissonerga disclose the same picture: renewed occupation of the standard circular buildings that contain monochrome ceramics rather than the exuberant Close Line style painted pottery of the Middle Chalcolithic (cat. 24). There are some indications that figurative artwork declined and that picrolites were often coarsely reworked. To the intra-site pit burials were added chamber tombs. No cemeteries like those at Souskiou have been located. Terminal radiocarbon dates place the end of the Late Chalcolithic around 2500 B.C., but as these dates are principally derived from structural timbers, a somewhat later date is realistically called for. Thus, there is strong evidence for the continuity of the Erimi Culture and little for calamity and wholesale abandonments at the end of the Middle Chalcolithic.[20]

There is also the possibility that earlier, broadly defined uniformity in Cyprus broke down into distinctive regional groupings. Such a group around the Bay of Morphou, it is claimed, already coexisted with Middle Chalcolithic Erimi.[21] The monochrome pottery of this Morphou group, however, is morphologically and decoratively so close to that from Late Chalcolithic Kissonerga and Lemba that it is difficult to concede a major time differential. These mainly unexcavated sites may indicate increased density of population in what was to become a core area in subsequent developments.

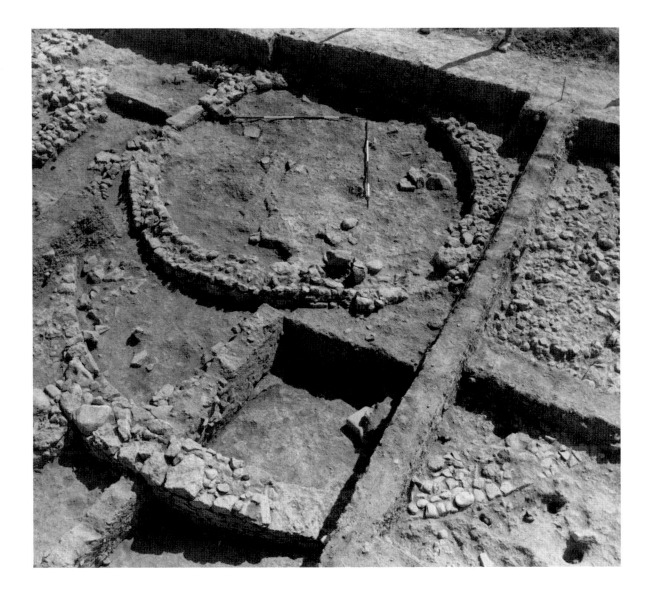

By core area is meant a region in which a number of sites exhibit ceramic and other traits that, on typological grounds, seem to be the earliest manifestations of the Early Bronze Age. This phenomenon is represented by the Philia Group, named after the cemetery of Philia-Vasiliko that yielded such novelties as Red Polished pottery, weaponry, annular shell rings, and biconical whorls in chamber tombs. It is likely that this group persisted for some time into the Early Bronze Age, when it coexisted with other local adaptations such as the North Coast Culture.[22]

There are several questions that pertain to this Philia Group, not least of which are its origins and the extent of its chronological overlap with the Erimi Culture. Discoveries at Kissonerga reveal the nature of many of the problems more clearly (fig. 5). We have already noted the occurrence of chamber tombs there in the context of a purely Erimi Culture. The Red Polished pottery and other Philia features just mentioned seem to occur in subsequent levels.

Figure 5. Two circular buildings of the mid-third millennium B.C. at Kissonerga-Mosphilia. The later, smaller structure is inside the partially excavated remains of the earlier, larger one.

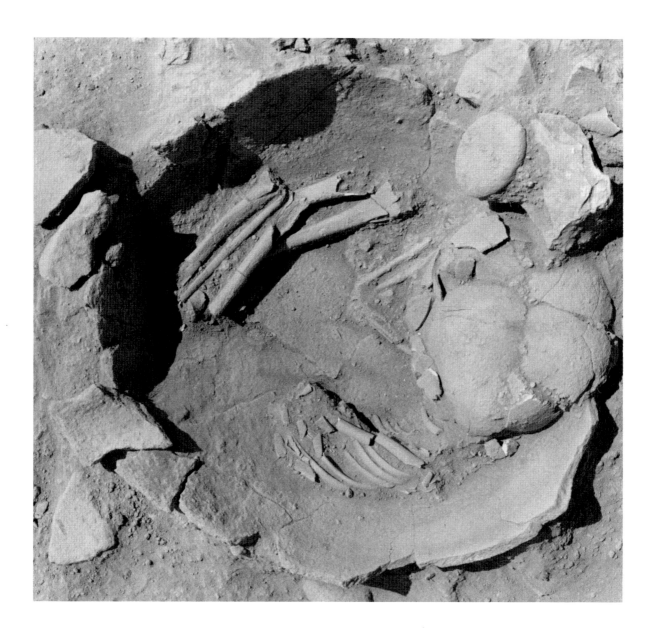

Figure 6. The earliest pithos burial in Cyprus, at Kissonerga-Mosphilia, circa 2500 B.C.

Unfortunately, those sparse levels were poorly preserved, hence the evidence is not yet sufficient for an early Philia settlement in Cyprus.[23] Nonetheless, two conclusions may be drawn here from the Kissonerga evidence. First, some features previously regarded as diagnostic of the Early Bronze Age, such as chamber-tombs and annular shell rings, already exist in Late Chalcolithic contexts. Second, Red Polished (Philia) pottery appears in the west after the last circular buildings and other long-lived Chalcolithic features.

This latter point is of considerable importance since it suggests a rapid collapse in the west of Cyprus. Unequivocal evidence from Lemba and from surveys confirms this crisis; the ultimate settlement at Lemba was destroyed by a fire in which its inhabitants were unable to retrieve such goods as rare copper items. Throughout the Paphos District, Late Chalcolithic settlements were abandoned and none, save Kissonerga, has yielded pottery of the succeeding period.

Unfashionable as it may be to refer to events as causative factors in prehistory, it seems as if the end of the western Chalcolithic was catastrophic and complete. It also seems likely that what we know as the Philia Group played some role in these events.

The origin of the Philia Group has been much debated, but even those who argue for an internal evolution recognize Anatolian influence in its pottery. Indeed, before the appearance of the latter in the west, the presence of pithos burials, stamp seals, and pottery with relief knobs and ribs represents evidence for links with Anatolia.[24] Recently discovered faience beads at Kissonerga, the earliest from the Mediterranean islands, corroborate the breakdown of Cypriot insularity before Philia.[25] Whatever its origins, therefore, there was a growing heterogeneity in Late Chalcolithic material culture.

Comparison of this new evidence from western Cyprus with that from the Aegean provides significant insights into the end of the Chalcolithic in Cyprus. Available chronological data allows us to synchronize this transition with the end of the Early Cycladic II period in the Aegean. According to several analysts, there was a complete disruption of Cycladic culture at that time, due in some part to Anatolian incursions. Factors include the abandonment of sites, the decline or disappearance of marble statuary, new Anatolian pottery forms, new metal types, and new burial practices, namely inhumations in pithoi (fig. 6).[26] These changes are precisely the kind that occurred in Cyprus, a coincidence that can hardly have been fortuitous. With regard to the Aegean, Machteld J. Mellink draws attention to the involvement of Tarsus and suggests that Anatolian raiders destroyed and sometimes settled, while Christos Doumas refers to refugee-pirates;[27] R. L. N. Barber prefers a more massive incursion.[28] Details will have varied from place to place in what appear to have been tumultuous times. For example, wheel-made vessels, *depa*, and large red platters—all pottery types of the succeeding horizon elsewhere—do not occur in post-Chalcolithic Cyprus, where earlier Anatolian forms found favor. It is becoming increasingly clear that the explanations for this watershed in terms of either insular developments or the presence of refugees from Anatolia are all too limited. The collapse of the Erimi Culture and the beginnings of the Cypriot Bronze Age need to be viewed in the much broader context of the strife and upheavals that profoundly affected much of the East Mediterranean, including the coastal regions of Anatolia, the Aegean, and the Greek mainland.

[1] Major surveys of this period (e.g., P. Dikaios, "The Stone Age," *The Swedish Cyprus Expedition* 4.1a [Lund, 1962], pp. 1-204; H. W. Catling, "Cyprus in the Neolithic and Chalcolithic Periods," *Cambridge Ancient History* 1.1[3] [Oxford, 1970], pp. 539-556) were composed prior to significant renewed research and so have become outdated to some extent. For surveys that take into account the results of more recent discoveries, see E. J. Peltenburg, *Recent Developments in the Later Prehistory of Cyprus*, Studies in Mediterranean Archaeology Pocketbook 16 (Göteborg, 1982); D. Bolger, *Erimi-Pamboula: A Chalcolithic Settlement in Cyprus*, British Archaeological Reports International Series 44 (Oxford, 1988), pp. 123-134; and especially E. J. Peltenburg, "The Chalcolithic Period of the History of Cyprus," *Makarios History of Cyprus* 1 (Nicosia, forthcoming).

[2] This revised scheme is treated more fully in Peltenburg, forthcoming (note 1).

[3] For these sites, see Peltenburg, forthcoming (note 1); for Kissonerga-Mosphilia, see E. J. Peltenburg et al., "Excavations at Kissonerga-Mosphilia, 1988," *Report of the Department of Antiquities, Cyprus* (1989), forthcoming; for Maa, see G. Thomas, "The Maa Chalcolithic Excavations," and D. Bolger, "Chalcolithic Maa: The Pottery," in V. Karageorghis and M. Demas, *Excavations at Maa-Palaeokastro, 1979-1986* (Nicosia, 1988), pp. 267-301.

[4] T. Watkins, "Philia-Drakos," in V. Karageorghis, "Chronique des fouilles et découvertes archéologiques à Chypre en 1970," *Bulletin de Correspondance Hellénique* 95 (1971), pp. 371-374.

[5] See, for example, A. South, "Figurines and Other Objects from Kalavassos-Ayious," *Levant* 17 (1985), pp. 65-79; E. J. Peltenburg, "The Evolution of the Cypriot Cruciform Figurine," *Report of the Department of Antiquities, Cyprus* (1982), pp. 12-14.

[6] See South (note 5).

[7] For this argument, see E. J. Peltenburg, "Early Copperwork in Cyprus and the Exploitation of Picrolite: Evidence from the Lemba Archaeological Project," in J. D. Muhly et al., eds., *Early Metallurgy in Cyprus, 4000-500 B.C.: Acta of the International Archaeological Symposium, 1-6 June 1981* (Larnaca, 1982), pp. 41-62.

[8] Z. A. Stos-Gale et al., "The Copper Trade in the South-East Mediterranean Region: Preliminary Scientific Evidence," *Report of the Department of Antiquities, Cyprus* (1986), p. 135.

[9] Lemba I might also belong to the end of the Early Chalcolithic: see E. J. Peltenburg et al., *Lemba Archaeological Project I: Excavations at Lemba Lakkous, 1976-1983*, Studies in Mediterranean Archaeology 70:1 (Göteborg, 1985), pp. 19-106, 314-316. Note the absence of intra-site burials at Late Neolithic Ayios Epiktitos-Vrysi and Philia-Drakos A, suggesting that cemeteries may have existed then, too.

[10] For these rectilinear structures, see Peltenburg et al., forthcoming (note 3).

[11] See conveniently F. G. Maier and V. Karageorghis, *Paphos: History and Archaeology* (Nicosia, 1984), pp. 24-34.

[12] For a preliminary account and interpretation, see E. J. Peltenburg, "The Beginnings of Religion in Cyprus," in Peltenburg, ed., *Early Society in Cyprus* (Edinburgh, 1989), pp. 108-126.

[13] For a recent survey of these statues, see D. Morris, *The Art of Ancient Cyprus* (Oxford, 1985), pp. 121-132.

[14] See, for the present, E. J. Peltenburg et al., "Kissonerga-Mosphilia 1987: Ritual Deposit, Unit 1015," *Report of the Department of Antiquities, Cyprus* (1988), pl. V.3-9.

[15] See Bolger (note 1), pp. 103-112; Maier and Karageorghis (note 11), pl. 8; Peltenburg et al. (note 14), pl. V.1.

[16] E.g., F. G. Maier and M.-L. von Wartburg, "Reconstructing History from the Earth, c. 2800 B.C.-1600 A.D.: Excavating at Palaepaphos, 1966-1984," in V. Karageorghis, ed., *Archaeology in Cyprus, 1960-1985* (Nicosia, 1985), pl. V.4.

[17] See E. J. Peltenburg et al. (note 9), pp. 35-36, for its context.

[18] Cf. Morris (note 13), p. 132, figs. 171-172; J. Thimme, ed., *Art and Culture of the Cyclades* (Karlsruhe, 1977), pls. 257-258. For the Anatolian parallels to cat. 32, see L. Vagnetti, "Two Steatite Figurines of Anatolian Type in Chalcolithic Cyprus," *Report of the Department of Antiquities, Cyprus* (1979), pp. 112-114.

[19] A considerable literature exists on this subject: see note 1 with references.

[20] As proposed by Catling (note 1), p. 555, prior to excavations in the west. Dikaios' Erimi may indeed have been abandoned, but the recovery of Late Chalcolithic material from another part of the site indicates that this was no more than a localized settlement shift: see H. Heywood et al., "Erimi Revisited," *Report of the Department of Antiquities, Cyprus* (1981), pp. 24-42.

[21] See T. F. Watkins, "The Chalcolithic Period in Cyprus: The Background to Current Research," *British Museum Occasional Papers* 26 (1981), pp. 16-18.

[22] "Philia" consists primarily of pottery; for this reason I prefer the term "group" to "culture" for what may be no more than a facies of the Early Bronze Age. For Philia-Vasiliko and other Ovgos Valley sites in the Bay of Morphou, see Dikaios (note 1), pp. 152-176; for the North Coast, see J. B. Hennessy, "Cyprus in the Early Bronze Age," *Australian Studies in Archaeology* 1 (1973), pp. 1-9.

[23] Stuart Swiny has claimed that such evidence exists at Sotira-Kaminoudhia (e.g., "The Philia Culture and Its Foreign Relations," in V. Karageorghis, ed., *Acts of the International Archaeological Symposium, "Cyprus Between the Orient and the Occident"* [Nicosia, 1986], pp. 29-44). Elsewhere, however, he notes that the diagnostic Chalcolithic material is mixed with Red Polished pottery

that could be as late as Middle Cypriot ("Sotira-Kaminoudhia and the Chalcolithic/Early Bronze Age Transition in Cyprus," in Karageorghis [note 16], pp. 114-124). The characteristics of these much earlier Chalcolithic remains—largely Middle Chalcolithic features such as Red-on-White sherds and part of a cruciform figurine—also cause problems since they argue for a lack of continuity at the site: these fragments may well have come from an unassociated site in the same place. Clearly Area A is the closest we have to a Philia settlement, but, according to its excavator, no final pronouncement can yet be made on its relationship to the nearby cemetery and other sites, and it would thus be premature, pending a final report, to incorporate the evidence of this site in interpretations of this transition.

[24] For pithos burials, see E. J. Peltenburg, "Lemba Archaeological Project, Cyprus, 1983: Preliminary Report," *Levant* 17 (1985), p. 59, pl. III.A; for the other aspects, see Peltenburg, forthcoming (note 1).

[25] They come from Late Chalcolithic burials: see Peltenburg et al., forthcoming (note 3).

[26] For a convenient survey, see R. L. N. Barber, *The Cyclades in the Bronze Age* (London, 1987), pp. 20-29, 137-141.

[27] See M. J. Mellink, "The Early Bronze Age in West Anatolia," in G. Cadogan, ed., *The End of the Early Bronze Age in the Aegean* (Leiden, 1986), pp. 139-152; C. G. Doumas, "EBA in the Cyclades: Continuity or Discontinuity?" in E. B. French and K. A. Wardle, *Problems in Greek Prehistory* (Bristol, 1988), pp. 21-29.

[28] Barber (note 26).

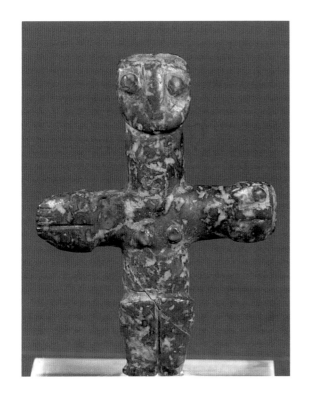

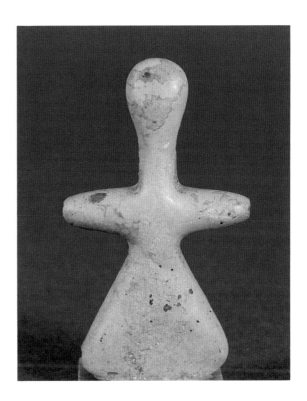

Double cruciform figure of dark green picrolite
(cat. 30).

Figure of steatite (cat. 34).

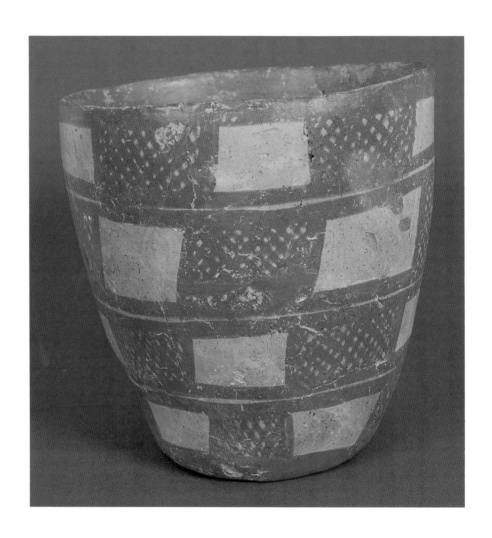

Bowl of Red-on-White ware from Kissonerga (cat. 26).

Catalogue of the Exhibition

Pavlos Flourentzos

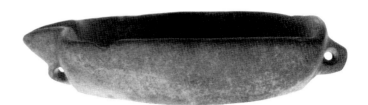

1. Shallow bowl of andesite
from Khirokitia
Aceramic Neolithic
Height: 5 cm; Length: 21 cm
Cyprus, No. KHIR 1276

The bowl is almost rectangular
with a flat base, sides that curve
inward, and an open spout at the
rim. Below the spout and on the
side of the bowl opposite the
spout are projections that are
pierced horizontally.

Bibliography: P. Dikaios, *Khirokitia*
(Oxford, 1953), pl. LVII.1276.

2. Part of an idol's head of
diabase from Khirokitia
Aceramic Neolithic
Height: 6.5 cm
Cyprus, No. KHIR 1093

The head has been broken and
filed along the edges. A series of
small holes were originally bored
along the edge, many of which
have been broken away. The
eyebrows and nose are marked
with raised strips; on the back a
vertical strip is scored with cross-
hatching. The surface is slightly
polished.

Bibliography: P. Dikaios, *Khirokitia*
(Oxford, 1953), pl. XCVII.1093.

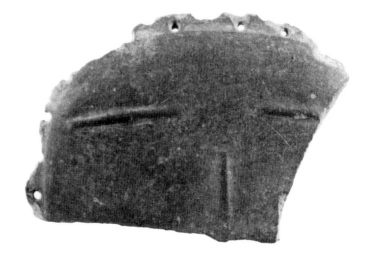

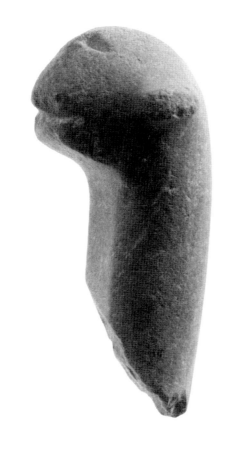

3. PROTOME OF AN ANIMAL OF
 DIABASE FROM KHIROKITIA
 Aceramic Neolithic
 Height: 11 cm
 Cyprus, No. KHIR 561

The animal is probably a lioness
or tiger, its eyes and mouth are
summarily indicated by oblong
cavities, the ears by raised projec-
tions.

Bibliography: P. Dikaios, *Khirokitia*
(Oxford, 1953), pl. XCVII.561.

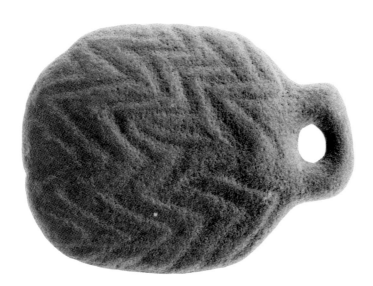

4. SHALLOW TRAY OF ANDESITE
 FROM KALAVASSOS-TENTA
 Aceramic Neolithic
 Height: 5.2 cm; Length: 26 cm
 Cyprus, No. 1940/IV-27/1

The tray has a single horizontal
loop handle and is decorated on
the underside with a zigzag
pattern in low relief.

Bibliography: P. Dikaios, *Khirokitia*
(Oxford, 1953), p. 235, pl. LXII.1; P.
Dikaios and J. R. Stewart, *The Swedish
Cyprus Expedition,* vol. 4.1a (Lund,
1962), fig. XII.6.

5. SMALL DEEP BOWL OF ANDESITE
 FROM KALAVASSOS-TENTA
 Aceramic Neolithic
 Height: 6.5 cm; Diameter: 8.5 cm
 Cyprus, No. K-T 493

The base of the bowl is flat; the
sides are rounded on the exterior.

Bibliography: Not previously published.

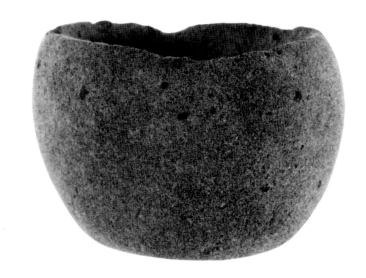

6. SMALL DEEP BOWL OF ANDESITE
 FROM KALAVASSOS-TENTA
 Aceramic Neolithic
 Height: 6.5 cm; Diameter: 12 cm
 Cyprus, No. K-T 253

The bowl has a flat base, inward
curving sides, and an open spout at
the rim.

Bibliography: V. Karageorghis, "Chronique
des fouilles à Chypre en 1977," *Bulletin de
Correspondance Hellénique* 102 (1978),
p. 909, fig. 70.

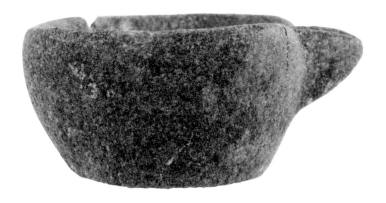

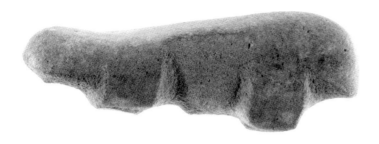

7. FRAGMENTARY FIGURE OF A
 QUADRUPED MADE OF ANDESITE
 FROM MARI-MESOVOUNI
 Aceramic Neolithic
 Height: 10.3 cm; Length: 27 cm
 Cyprus, No. 1978/XII-19/1

The body is oblong with a long
neck and large, prominent tail.
The head and lower parts of the
legs are missing.

Bibliography: I. Todd, "Vasilikos Valley
Project, 1977-1978: An Interim Report,"
*Report of the Department of Antiquities,
Cyprus* (1979), pl.II.3.

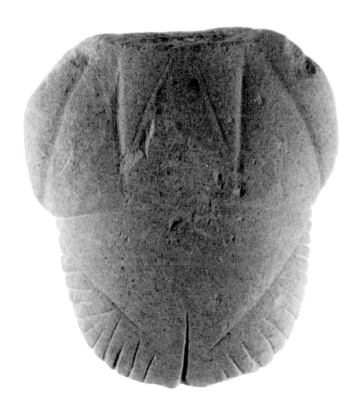

8. FEMALE IDOL OF ANDESITE
 FROM AYIOS THOMAS, NEAR
 PALAEOMYLOS
 Aceramic Neolithic
 Height: 13.5 cm
 Cyprus, No. LM 795

The flat oval body has no head,
and the arms and legs are suc-
cinctly indicated with incised
lines. The waist and female
genitals are marked with horizon-
tal and vertical grooves. There are
short radiating notches around
the lower half of the idol.

Bibliography: H. G. Buchholz and V.
Karageorghis, *Prehistoric Greece and Cyprus*
(London, 1973), p. 464, no. 1694.

9. IDOL OF DARK ANDESITE FROM KIDASI

Late Neolithic

Height: 16.5 cm

Cyprus, No. PM 1503

The arms and legs of the idol are very rudimentary. The large, round, flat head carries incised grooves indicating the eyes, nose, mouth, and hair.

Bibliography: H. G. Buchholz and V. Karageorghis, *Prehistoric Greece and Cyprus* (London, 1973), p. 464, no. 1689.

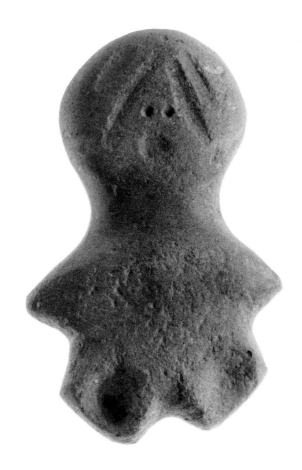

10. FIDDLE-SHAPED IDOL OF LIMESTONE FROM SOTIRA

Late Neolithic

Height: 16 cm

Cyprus, No. Sotira 106

This very abstract idol has the legs separated by a deep groove, the head indicated with a curved outline. Rather than a human figure, the idol seems simply the combination of male and female genitals.

Bibliography: P. Dikaios, *Sotira* (Philadelphia, 1961), p. 201, pls. 91.106, 102.106.

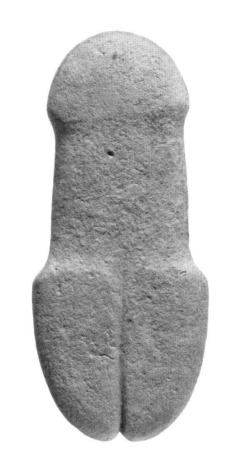

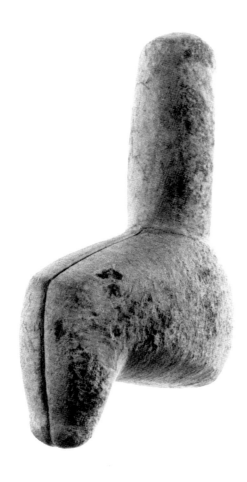

11. Seated figure of limestone from Sotira

Late Neolithic

Height: 14 cm; Length: 11 cm

Cyprus, No. 1981/VIII-19/1

The legs, divided at a deep angular central groove, are bent at the knees. The flat shins are bowed out and the small feet curled up. The rounded outline of the hips forms the widest point of the figure. The flat, elongated neck is surmounted by a mushroom-shaped head devoid of facial features.

Bibliography: H. and S. Swiny, "An Anthropomorphic Figurine from the Sotira Area," *Report of the Department of Antiquities, Cyprus* (1983), p. 56, fig.1, pl. VI.

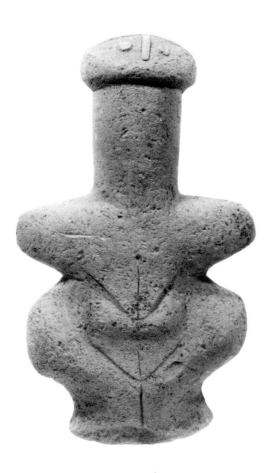

12. Fiddle-shaped figure of limestone from Lemba

Middle Chalcolithic

Height: 36 cm

Cyprus, No. LL 54

The figure has outstretched arms and a head that is tilted back atop a long cylindrical neck. The nose and eyes are in raised relief, the hairline incised. The hips are flat and very wide; the legs and feet, separated by an incised line, terminate in a round splayed base. The body is incised with two bisected V's, the lower one at the pubic area, the other at the breasts. The belly bulges slightly.

Bibliography: E. J. Peltenburg, *Lemba Archaeological Project I: Excavations at Lemba-Lakkous, 1976-1983,* Studies in Mediterranean Archaeology 70:1 (Göteborg, 1985), pl. 45.1, fig. 18.
(See also figs. 3 and 4)

13. CRUCIFORM FIGURE OF LIME-
STONE SAID TO BE FROM
SOUSKIOU
Middle Chalcolithic
Height: 39.5 cm
Malibu, J. Paul Getty Museum
83.AA.38

The idol is complete but not in-
tact; the left arm was broken and
mended in antiquity. The form is
an enlarged version of more fam-
iliar small picrolite figurines.
Squatting with outspread arms, this
figure has broad, flat thighs, deeply
cut grooves separating the breasts
and lower legs, and incised lines in-
dicating the toes. The arms are
decorated with rope patterns that
may indicate jewelry. The head, set
on a tall neck, is tilted slightly back
and shows well-developed and fully
carved facial features: round staring
eyes, prominent brows and hair, and
a small incised mouth.

Bibliography: J. Thimme, *Kunst und Kultur
der Kykladeninseln im 3. Jahrtausend v. Chr.*
(Karlsruhe, 1976), no. 573 [trans. P. Getz-
Preziosi, *Art and Culture of the Cyclades*
(Chicago, 1977), no. 573.]; J. Kara-
georghis, *La grande déesse de Chypre et son
culte* (Lyons, 1977), p. 32; E. Peltenburg,
"Chalcolithic Figurine from Lemba,
Cyprus," *Antiquity* 51 (1977), pp. 140-
143; J. Crouwel, "Cypriote Chalcolithic
Figurines in Amsterdam," *Report of the
Department of Antiquities, Cyprus* (1978),
p. 33; V. Karageorghis, *Ancient Cyprus*
(Baton Rouge, 1981), p. 16; P. Getz-
Preziosi, "An Early Cypriote Sculpture,"
J. Paul Getty Museum Journal 12 (1984),
pp. 21-28; F. G. Maier and V. Karageor-
ghis, *Paphos: History and Archaeology*
(Nicosia, 1984), pp. 34-35; P. Getz-
Preziosi, *Early Cycladic Sculpture* (Malibu,
1985), pp. 85-87; S. Lubsen-Admiraal
and J. Crouwel, *Cyprus and Aphrodite*
('s- Gravenhage, 1989), cat. no. 40, pp.
107-108, 151.

(See cover)

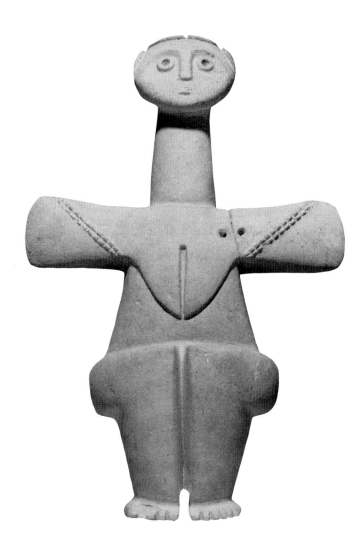

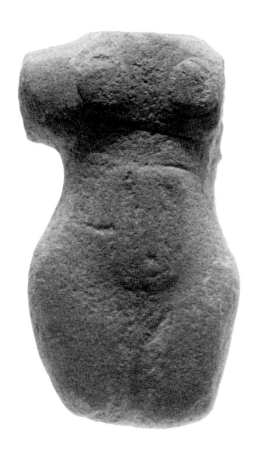

14. FEMALE FIGURE OF DIABASE FROM ERIMI

Chalcolithic

Height: 10.8 cm

Cyprus, No. LM 623/2

The head and left arm of the figure are missing. The right arm is short and stump-shaped. The breasts are represented in very low relief, the pubic region by a lightly incised V. The legs, divided by a central incised line in front and back, descend from large hips and protruding buttocks.

Bibliography: L. Vagnetti, "Two Chalcolithic Stone Figurines from Erimi," *Report of the Department of Antiquities, Cyprus* (1987), p. 19, pl. V.3-5.

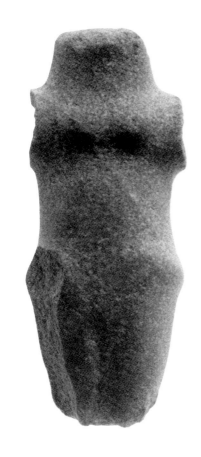

15. FEMALE FIGURE OF ANDESITE FROM ERIMI

Chalcolithic

Height: 14.4 cm

Cyprus, No. LM 623/1

The breasts and hips of this figure are indicated in low relief, the division of the legs in front and back by an incised line. A streak of white color in the stone crosses the figure from the right shoulder to the left hip. The head and arms are missing, and a large chip has been lost from the right leg.

Bibliography: L. Vagnetti, "Two Chalcolithic Stone Figurines from Erimi," *Report of the Department of Antiquities, Cyprus* (1987), p. 19, pl. V.1-2.

16. MINIATURE FIGURE OF TERRA
COTTA FROM ERIMI
Early to Middle Chalcolithic
Height: 4.1 cm
Cyprus, No. Erimi 977

The figure represents either a
pregnant female or a baby. The
head has no facial details, and the
arms are indicated by two simple
projections at the shoulders. A
deep groove runs vertically
through the center of the body.

Bibliography: Not previously published.

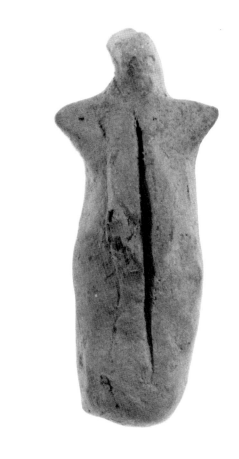

17. HEAD OF A FIGURE OF TERRA
COTTA FROM ERIMI
Early to Middle Chalcolithic
Height: 7 cm
Cyprus, No. Erimi 743

The oval face has a high broad
forehead surrounded by hair in
low relief. The nose, eyebrows,
and eyes are also fashioned in
relief, with depressions across the
eyes and under the nose to
indicate nostrils.

Bibliography: P. Dikaios, "The
Excavations at Erimi, 1933-1935," *Report
of the Department of Antiquities, Cyprus*
(1936), pl. XXVIII.1.

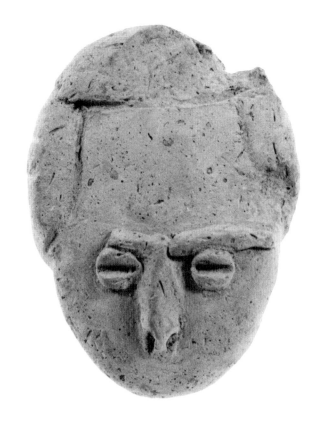

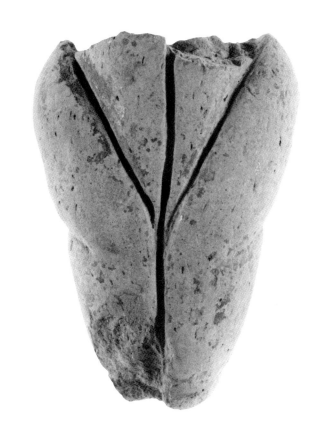

18. LOWER HALF OF A FEMALE FIGURE OF TERRA COTTA FROM ERIMI

Early to Middle Chalcolithic

Height: 9 cm

Cyprus, No. Erimi 856

The pubic region is prominently indicated by deep grooves between the steatopygic hips. The division between the legs is an incised line in front and back. There are traces of red pigment on the surface.

Bibliography: P. Dikaios, "The Excavations at Erimi, 1933-1935," *Report of the Department of Antiquities, Cyprus* (1936), pl. XXVIII.9.

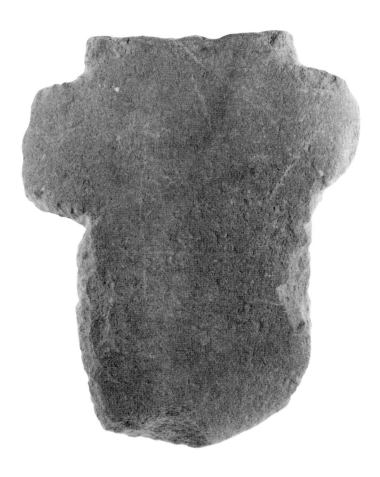

19. IDOL OF ANDESITE FROM KOUKLIA

Chalcolithic

Height: 23.5 cm

Cyprus, No. KD 53.1

The cruciform body has no head. The arms are stump-shaped.

Bibliography: F. G. Maier and V. Karageorghis, *Paphos: History and Archaeology* (Nicosia, 1984), pl. 23.

20. Mortar and pestle of
andesite from Kouklia

Chalcolithic
Height of pestle: 10.5 cm
Diameter of mortar: 10 cm
Cyprus, No. T.E.T. 76

The disk-shaped mortar is
extremely shallow.

Bibliography: Not previously published.

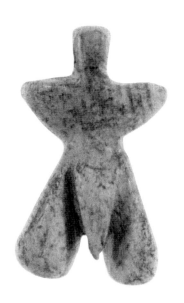

21. Anthropomorphic pendant of bone from Kouklia
Chalcolithic
Height: 3 cm
Cyprus, No. KC 754

The pendant represents a male figure with spread legs and a large, prominent phallus. The head has no facial detail, and the arms are summarily indicated by small raised projections at the shoulders.

Bibliography: Not previously published.

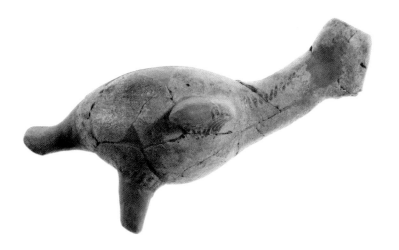

22. Vase of Red-on-White ware from Kouklia
Chalcolithic
Length: 20 cm
Cyprus, No. KX 51

The vase is shaped like a duck with a nearly ovoid body, prominent wings, a tail, and two legs. The long neck terminates in a crudely rendered head. A hole at the top of the head is the vase's mouth.

Bibliography: Not previously published.

23. NECKLACE OF DENTALIA FROM
 SOUSKIOU-VATHYRKAKAS
 Middle Chalcolithic
 Length: 38 cm
 Cyprus, No. T.3/2

The dentalia of the necklace
alternate with very small human
cruciform figures made of gray
picrolite.

Bibliography: V. Karageorghis, *The
Civilization of Prehistoric Cyprus* (Athens,
1976), p. 56, fig. 30.

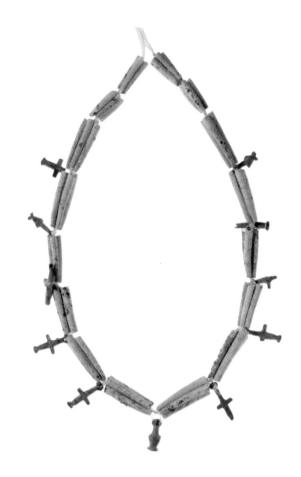

24. FLASK OF RED-ON-WHITE WARE
 FROM KISSONERGA
 Middle Chalcolithic
 Height: 23.5 cm
 Cyprus, No. KM 477b

The globular body has a pointed
base, tall straight neck, and
everted rim. A broad red band at
the mouth and at the base frame a
white-ground field decorated with
latticed, flame-shaped patterns
and vertical lines.

Bibliography: F. G. Maier and V. Kara-
georghis, *Paphos: History and Archaeology*
(Nicosia, 1984), pl. 20.

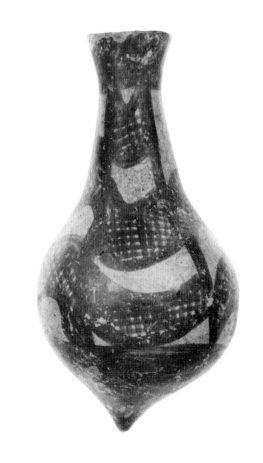

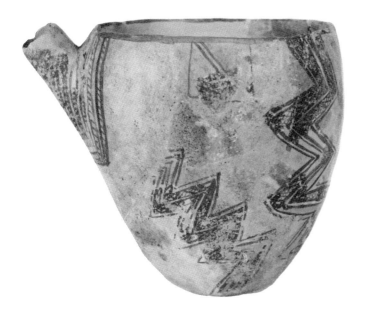

25. Spouted bowl of Red-on-White ware from Kissonerga

Middle Chalcolithic

Height: 21.7 cm;

Diameter: 19.5 cm

Cyprus, No. KM 400

This bowl has a deep body ending in a flat base, a slightly in-turned rim, and a tubular spout extending from the widest part of the bowl just below the rim. It is decorated with vertical rows of chevrons that are partially latticed, square panels filled with checks, and hatched lines below the spout.

Bibliography: E. J. Peltenburg, "Lemba Archaeological Project, Cyprus 1982," *Levant* 16 (1984), p. 61, fig. 4.

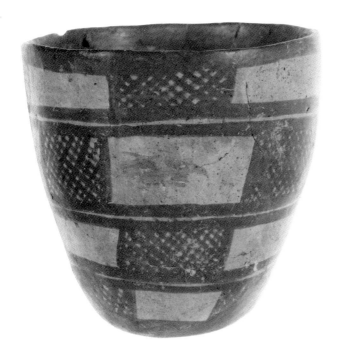

26. Bowl of Red-on-White ware from Kissonerga

Middle Chalcolithic

Height: 17 cm; Diameter: 16.5 cm

Cyprus, No. KM 87/1346

This deep bowl has a bell-shaped body with flaring sides and a flat base. The exterior is decorated with latticed checks, the interior with solid red slip.

Bibliography: Not previously published.

(See color plate on p. 24)

27. Bowl of Red and Black Stroke Burnished ware from Kissonerga

Late Chalcolithic
Height: 11.5 cm; Diameter: 18.5 cm
Cyprus, No. KM 1258

This deep bowl has flaring sides and an omphalos base. The surface is differentially fired black and red in irregular patterns and burnished.

Bibliography: Not previously published.

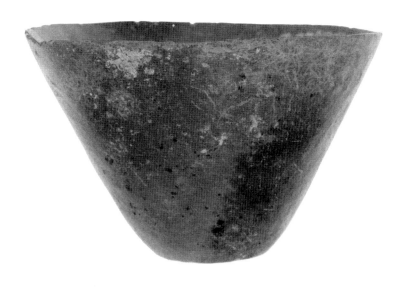

28. Idol of calcarenite from Kissonerga

Middle Chalcolithic
Height: 16.1 cm
Cyprus, No. KM 1471

The truncated, outstretched arms of this figure are wedge-shaped in section and round at their ends. The upper torso swells below the arms to breasts indicated by a bisected, V-shaped groove, tapers at the waist, and swells again to a rounded belly. The broad rounded hips taper sharply through the legs, which are separated by a vertical incision. The out-turned feet are separated from the legs with horizontal incisions. The back of the figure is less fully modeled than the front.

Bibliography: E. J. Peltenburg et al., "Kissonerga-Mosphilia 1987: Ritual Deposit, Unit 1015," *Report of the Department of Antiquities, Cyprus* (1988), pt. 1, pl. V.3.

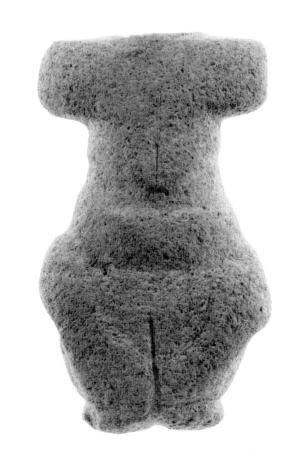

40

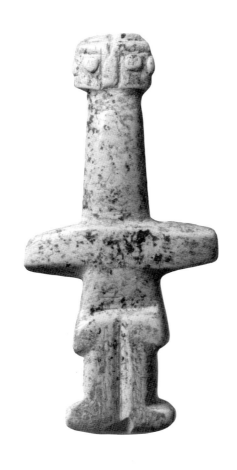

29. Cruciform idol of steatite said to be from Paphos-Souskiou

Chalcolithic

Height: 8.3 cm; Width: 4.1 cm

Houston, The Menil Collection 74-51DJ

The figure, of a polished light green steatite with several incrustations and scratches, has a long, thick neck and a small janus head with large ears and eyes and a flat nose. The schematic arms are horizontal to the body, and the knees and feet are rendered in profile.

Bibliography: J. Thimme, *Kunst und Kultur der Kykladeninseln im 3. Jahrtausend v. Chr.* (Karlsruhe, 1976), no. 572 (illus.) [trans. P. Getz-Preziosi, *Art and Culture of the Cyclades* (Chicago, 1977), no. 572]; *La Rime et la raison: Les collections Menil,* ex. cat. (Galeries Nationales du Grand Palais, Paris, April 17-July 30, 1984), no. 11 (illus.); *The Menil Collection: A Selection from the Paleolithic to the Modern Era* (New York, 1987), no. 8 (illus.).

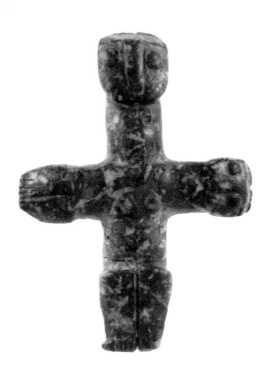

30. Double cruciform figure of dark green picrolite

Chalcolithic

Height: 5.2 cm

Cyprus, No. W 291

A flat head with short hair parted in the middle and eyes and nose in relief is set on a long neck. The arms of the one figure form a second figure with the head to the right. The breasts are cursorily indicated. The legs, bent at the knees, are separated by a groove.

Bibliography: Not previously published. (See color plate on p. 23)

31. CRUCIFORM IDOL OF GRAY
 STEATITE
Chalcolithic
Height: 13.5 cm
Cyprus, No. W 290

A small flattened head with details
of the face in relief and the hair
indicated by scoring is set on a very
elongated neck. The knees are
drawn up sharply and a deep groove
separates the legs. The angular
body has outstretched arms that are
incised with an oblique lattice
pattern.

Bibliography: H. G. Buchholz and V.
Karageorghis, *Prehistoric Greece and Cyprus*
(London, 1973), p. 466, 1701a, b.

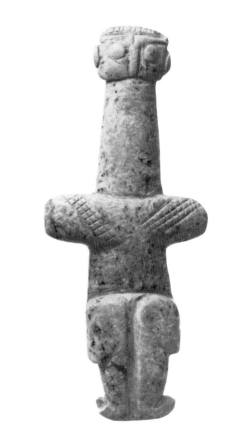

32. CRUCIFORM FEMALE IDOL OF
 STEATITE SAID TO BE FROM
 PAPHOS-SOUSKIOU
Chalcolithic
Height: 7.9 cm; Width: 6.6 cm
Houston, The Menil Collection
76-17DJ

The figure, of a polished light green
steatite, has a long neck and extend-
ed arms. The left arm, with four
fingers indicated, is turned down-
ward; the right arm, also with four
fingers indicated, is turned upward.
The figure's legs are articulated by a
deep incised line; the toes of the two
legs are joined with only seven toes
indicated. The figure is intact with
a few minor surface abrasions (pick
marks) diagonally across the torso.

Bibliography: *La Rime et la raison: Les collections
Menil,* ex. cat. (Galeries Nationales du Grand
Palais, Paris, April 17-July 30, 1984), no. 10
(illus.); *The Menil Collection: A Selection from
the Paleolithic to the Modern Era* (New York,
1987), no. 7 (illus.).

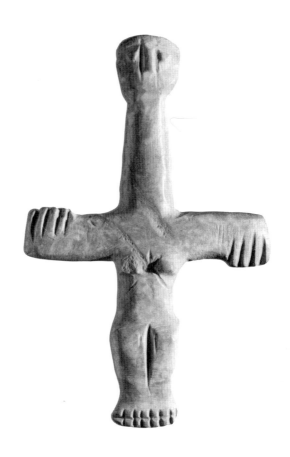

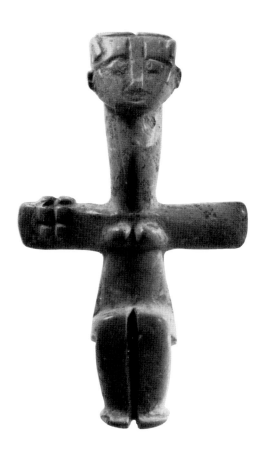

33. CRUCIFORM IDOL OF LIGHT GREEN
STEATITE FROM SOUSKIOU

Chalcolithic

Height: 7.3 cm

Cyprus, No. 1981/V-4/10

A large triangular head with facial
features in relief is set on a long thin
neck. The large, almond-shaped
eyes are cut in relief below incised
eyebrows; the ears are in low relief
as is the hair. An incision outlines
the long nose and the mouth. The
arms are outstretched, the right one
carrying two rows of raised bosses.
The breasts are shown in prominent
relief, the legs drawn up and separated by a groove. The back is flat
and carefully polished.

Bibliography: L. Vagnetti, "Preliminary Remarks on Cypriote Chalcolithic Figurines," *Report of the Department of Antiquities, Cyprus* (1974), pl. V.3; Vagnetti, "Figurines and Minor Objects from a Chalcolithic Cemetery at Souskiou-Vathyrkakas," *Studi Micenei ed Egeo-Anatolici* 72 (1980), pl. I.2.

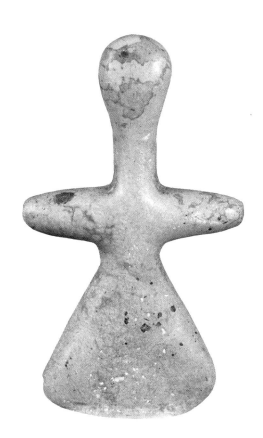

34. FIGURE OF STEATITE

Chalcolithic

Height: 6.6 cm

Cyprus, No. 1976/VIII-10/1

The simplified abstract forms of this
figure show an oval head on a long
cylindrical neck. Outstretched arms
join directly the unarticulated, sack-
shaped body.

Bibliography: L. Vagnetti, "Two Steatite Figurines of Anatolian Type in Chalcolithic Cyprus," *Report of the Department of Antiquities, Cyprus* (1979), pl. XII.1.

(See color plate on p. 23)

35. FEMALE IDOL OF STEATITE SAID
 TO BE FROM PAPHOS-SOUSKIOU
 Chalcolithic
 Height: 7 cm; Width: 3.8 cm
 Houston, The Menil Collection
 CA 6106

The figure, of a polished dark
green steatite, appears to be
seated. The head and right leg
(once possibly extended) are now
missing. A deep incised line be-
ginning at the bottom of the neck
runs the length of the figure. The
figure's arms are extended with
no indication of fingers.

Bibliography: *La Rime et la raison: Les
collections Menil*, ex. cat. (Galeries
Nationales du Grand Palais, Paris, April
17-July 30, 1984), no. 9 (illus.).

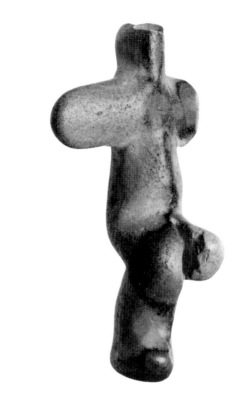

36. CRUCIFORM IDOL OF STEATITE
 FROM SOUSKIOU
 Chalcolithic
 Height: 6 cm
 Cyprus, No. PM 2125

The small oval head on a long
neck has facial features that are
indicated with incised lines and
dots. The outstretched arms are
decorated with a large check
pattern. The legs, bent at the
knees, are separated by a groove.
The toes are incised.

Bibliography: Not previously published.

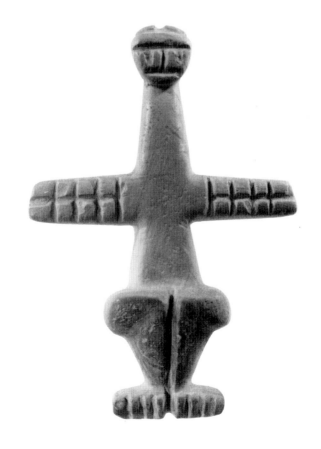